When God Rewrites Your Story

Six Keys to a Transformed Life

From Namesake

Jessica LaGrone

Abingdon Press
Nashville

This book is printed on acid-free paper.

ISBN 978-1-4267-6354-0

All Scripture quotations, unless otherwise indicated, are taken from the Holy Bible, New International Version®, NIV®. Copyright © 1973, 1978, 1984, 2011 by Biblica, Inc.™ Used by permission of Zondervan. All rights reserved worldwide. www.zondervan.com. The "NIV" and "New International Version" are trademarks registered in the United States Patent and Trademark Office by Biblica, Inc.™

Scripture quotations marked CEB are from the Common English Bible. Copyright © 2011 by the Common English Bible. All rights reserved. Used by permission. www.CommonEnglishBible.com.

Scripture quotations marked (ESV) are from The Holy Bible, English Standard Version® (ESV®), copyright © 2001 by Crossway, a publishing ministry of Good News Publishers. Used by permission. All rights reserved.

Scripture quotations marked WEB are from the World English Bible.

Library of Congress Cataloging-in-Publication Data on file

13 14 15 16 17 18 19 20 21 22—10 9 8 7 6 5 4 3 2

MANUFACTURED IN THE UNITED STATES OF AMERICA

Contents

Introduction

Have you ever thought of your life as a story? Just like the characters in the Bible, your life tells a story. And just as God was intimately involved in their stories, He wants to be intimately involved in your story, too.

When we read the stories of many people who encountered God in the Bible, we see that God rewrote their stories and changed their lives, giving them new destinies and even new names. God still longs to change our lives today, giving us new destinies and new names, when we take on the name of His Son, Jesus, and choose to follow Him as new creations in Christ. God wants to rewrite our stories, offering each of us an identity that shines with the purpose for which we were created, as we become more and more like Him. The result is a transformed life—one that brings God glory for His name's sake.

We can learn much about this process of transformation from the stories of biblical characters who came to know God and were never the same. This little book presents a snapshot of six different stories: Abraham and Sarah, Jacob, Naomi, Daniel, Peter, and an unnamed woman. Each story highlights a key insight we can gain related to the transformation that God wants to bring in our own lives. These six keys to a transformed life are intended to help you catch a glimpse of the new story God desires to write for you. It is my prayer that as you read these stories, you will come to know God in a deeper and more personal way and give Him permission to rewrite your own life story.

1

Believe God and Wait on Him

Abraham and Sarah

If we want to experience the transformation that God desires to bring in our lives, an important first step is to believe God. Not only must we believe *in* God; we must believe what God says. We must believe God's promises are true and that He has the power to bring them to pass, even when our circumstances tempt us to believe otherwise. This often involves placing ourselves in God's hands as we wait on His timing.

A Hopeful Couple

When I think of believing God and waiting on His timing, I think of Abraham and Sarah—known to us first in the Bible as Abram and

Sarai. In Hebrew, Abram's name literally means "Exalted Father." Though it may seem strange to us that his parents named their newborn "Father," to them it represented their dreams for their son's prosperity, which in their day meant growing up to be a father with lots of children.

Abram did grow up, and he married Sarai, whose name means "Princess." But even after being married so long that their friends had children and even grandchildren, Abram and Sarai remained childless. In a culture that placed such high value on the number of offspring one had, this was a devastating blow.

Then God began to make outlandish and epic promises to Abram and Sarai in their old age, declaring that they would become the parents of many offspring—a great nation (Genesis 12:1-4)—and later "many nations" (Genesis 17:1-4). God even gave Abram a powerful visual to go with this promise, telling him that his offspring would be as numerous as the stars (Genesis 15:5).

The promise of God's blessings in Abram and Sarai's lives was so overwhelming that their lives were utterly transformed by God. From the moment God made the promise, everything was different. Even their names had to be changed.

Never the Same

God said to Abraham, "No longer will you be called Abram; your name will be Abraham, for I have made you a father of many nations.... As for Sarai your wife, you are no longer to call her Sarai; her name will be Sarah. I will bless her and will surely give you a son by her. I will bless her so that she will be the mother of nations; kings of peoples will come from her" (Genesis 17:5, 15-16).

In light of the big changes God wanted to make in Abram and Sarai's lives, the changes in their names seem so small. In fact, the difference was just one letter each in Hebrew. But when God makes changes, the tiniest adjustment can communicate big things for us, our futures, and those whose lives we will impact.

Abram and Sarai each received the same letter as an addition to their names. In Hebrew the letter is called "Hey," similar to our "H." Abram became Abraham and Sarai was renamed Sarah. The addition of that one letter shifted the meaning of their names to fit God's plan for their future. Abram, "The Exalted Father," was now Abraham, "The Father of Many Nations." And Sarai, "My Little Princess," was now "A True Princess."

Hearing their new names spoken by God must have been an awesome moment, one where God painted a clear picture of the future He had in mind for them.

Waiting on God

Abraham and Sarah received awesome promises from God, but what they did not receive was a timeline for when those promises would be fulfilled. They learned quickly that trusting this God and His promises meant a lot of waiting, hoping, and praying.

There were a few years when my life felt like one big waiting room. My heart's desire was to become a mom, but my body just wasn't cooperating. After a couple of years in the waiting room of my regular ob-gyn, I moved on to the bigger and more expensive waiting room of a specialist, and a lab, and an operating room, and lots of other places where it seemed like all I could do was...wait.

After what seemed like an eternity of trying, the joy of finding out we were expecting our first baby was quickly eclipsed by the devastating news that I had miscarried. That led to more

tests, more doctors' visits, and more waiting as we anticipated answers and results.

Abraham and Sarah's lives were full of waiting for their longing for a child to be fulfilled. From their perspective it must have seemed that their prayers were getting harder and harder to answer because of their advancing age, but to a God who loves a challenge, the timing was just right. The more difficult something is to make happen, the more God enjoys rolling up His sleeves and impressing the world by doing what only He can accomplish. Waiting for the blessing can often be part of the blessing itself, since we have to rely on God in new and unexpected ways. Abraham and Sarah's longings were finally satisfied by the arrival of their little boy, Isaac, the fulfillment of both their dreams and God's promises.

I never would have chosen the path that my husband and I went down over those years of waiting. But I recognize now that the waiting strengthened my marriage and my relationship with God more than I could have imagined at the time. Those years gave me a deep appreciation for Abraham and Sarah. When I read their story of waiting, I see their years of discouragement and anguish but also their growing trust and hope in

God. Abraham and Sarah had different hearts, a different marriage, and a different outlook on God's promises after twenty-five long years of waiting.

Believing and trusting God doesn't mean that our prayers will be instantaneously answered, as if God were some cosmic vending machine ready to dispense our wishes and wants. Instead, it means that our waiting and longing can become a tool that transforms us rather than an obstacle to happiness and fulfillment. Choosing to believe God's promises and trust God's goodness means that we turn our waiting over to Him. When we do, moments when we impatiently thought nothing was happening at all can become some of the most productive, transformational times of our lives.

2

Let Go and Grab onto God

Jacob

When God rewrites our stories, He changes us. Change is the essence of transformation. Yet there can be no change unless we learn to let go of the past, of what has been. Still, letting go is not enough. By our very nature, we need the security of holding onto something. If we're not holding onto one thing, we'll look for something else to take its place. So, if we want God to rewrite our stories and change us, we must let go and grab onto God.

Jacob in the Old Testament learned this the hard way, after many years of struggle and heartache. His story encourages us to let go and grab onto God.

Born Grabby

After years of infertility and a trying pregnancy, Rebecca gave birth to twins. She and her husband, Isaac, named their firstborn Esau, which means "Hairy," because he was covered from head to toe with red hair. As Esau was born they noticed that a little hand was tightly gripping his heel. They took one look at that little hand and named their second born Jacob, which means "Grabby."

Perhaps more than any other story in the Bible, Jacob's character was shaped from the beginning by his name. It not only reflected the circumstances of his birth, since he was grabbing at his brother's heel, but in some contexts Jacob also means Deceiver, "Taker of What Is Not His." This unfortunate connotation had a deep impact on the person Jacob would become and affected every aspect of his life, beginning with his relationship with his twin brother, Esau.

Unwilling to Settle for Second

Jacob and Esau's sibling rivalry began early: in the womb. Their mother, Rebecca, even cried out to God because their prenatal scuffles were so painful.

As soon as they were born, their inheritance and place in the family were sealed for life.

As the second-born, Jacob would have inherited only a fraction of his parents' wealth, while his older brother, Esau, would receive a larger share called the birthright. Then, upon their father's death, Esau would receive the Blessing as well, a spiritual inheritance on top of the final confirmation of the material one. This meant the elder would succeed the father as patriarch of the family when he died, and that the younger would be subservient to his sibling as the ruler and owner of the estate as well as the spiritual leader. This hierarchy certainly played a part in the conflict between the two brothers. And the conflict between them no doubt was fueled by the preferential treatment of their parents. Scripture tells us that Rebecca preferred Jacob and Isaac preferred Esau.

Riddled with envy and discontent, Jacob spent his childhood and early adulthood longing for what was not his and scheming about how to get it. So when he saw the moment to take advantage of his brother, he grabbed it.

One day Esau came home famished from a long hunting trip to find that Jacob had just dished

himself up the last bowl of food in the house. Preparing a meal could take all day, and Esau was hungry *now*.

When Esau asked for the stew, Jacob said he could have it if Esau gave him his birthright. Esau agreed. His choice to alleviate his hunger rather than hold onto his full inheritance is puzzling to us. Why settle for one bowl of food when someday you will own all the bowls in the house—and the house itself? The truth is that instant gratification sometimes gets the best of all of us. Short-term pleasure is gratifying, but long-term regrets can be shattering. They certainly were for Esau.

Jacob, too, experienced a gain and a loss in that moment. He gained exactly what he set out to grab in the first place. But what he lost was a brother, as well as any sense of goodness in himself.

Jacob had the birthright, but he wanted the blessing as well. An opportunity arose when his father, Isaac, lay dying. Isaac knew he wanted to pass the blessing along to his older son, so he sent Esau out to hunt for and prepare a last meal. That's when Rebekah engaged Jacob in her plan of deceit that involved preparing a meal, dressing Jacob in his brother's clothes that she happened to have ready for such an occasion, and putting goatskins

on Jacob's hands and neck to cover his smooth skin. Jacob would trick Isaac into believing he was Esau and receive the blessing due his brother. And that is exactly what happened.

When Esau returned with game for his father and requested his blessing, he was told that it was too late. Once again Jacob the Deceiver and Supplanter had stolen what belonged to his brother.

Jacob spent the first half of his story struggling to take what was not rightfully his. He would spend the second half of his life running away from the mistakes he made.

Dissatisfied

Having poisoned his relationships with his family, Jacob ran away to the home of his Uncle Laban, his mother's brother. There he fell in love with Laban's younger daughter, Rachel, and his Uncle Laban tricked him into marrying her less desirable older sister instead. Jacob woke up the morning after his wedding, hung over and bleary, and discovered that he had married the wrong sister. He said to his Uncle Laban, "You've deceived me!" Essentially he was saying,

"You've Jacobed me!" What satisfying irony that Jacob had now been tricked—so that what should have belonged to the younger daughter was given instead to the older, the exact opposite of Jacob's trickery in his own family.

Today the simple solution would be divorce. Back then the answer was to marry the other daughter too. So that is what Jacob did, and he made himself at home and stayed for a few decades—long enough to swindle his uncle, now his father-in-law, out of most of his best livestock.

Despite his material success, Jacob was dissatisfied, and he began to miss the home and family he had left behind. Eventually that homesickness bothered him enough to make the decision to face the consequences of his actions and return to his homeland. On the very last leg of his journey, Jacob learned that he was about to face with his brother, Esau, who had every right to be furious, even after all these years. The night before the confrontation, Jacob took everything he had accumulated—everything and everyone he had grabbed, deceived, or swindled to get—and sent them across a river called Jabbok, which literally means "Emptying." Then he sat down alone.

Finally, Jacob was by himself in the quiet to consider all that he had done with his life. It probably was the first time Jacob had been alone with his thoughts in a long time—only he wasn't alone for long.

An Encounter with God

In Genesis 32:24 we read: "So Jacob was left alone, and a man wrestled with him till daybreak." Though biblical scholars are divided on exactly who this "man" was that wrestled with Jacob, we find a clue in the fact that several passages in the Bible use the word "man" to describe what some scholars interpret as a visitation from the Divine. What's more, in Hosea 12 we read, "In the womb he grasped his brother's heel; as a man he struggled with God" (verse 3).

It seems clear that this all-night wrestling match was a Divine encounter. That night forced Jacob to stop grasping at things and ambitions and grab hold of God Himself.

Jacob wrestled with God to the point of injury, and he was even bold enough to ask his wrestling partner for a blessing. The last time Jacob had asked for a blessing (from his father), he had lied,

misrepresented himself, and taken on the identity of his brother. This time when Jacob asked for a blessing (from his heavenly Father), he was again asked in return, "What is your name?" His answer was both an introduction and a confession: "I am Jacob," he said truthfully. Deceiver. Swindler. Taker of what is not mine.

God must have been satisfied with that answer, because He knew it took a lot for Jacob to speak the truth at last. Even so, He wasn't satisfied with the man standing before Him. At that moment, God changed Jacob's name. Jacob the Deceiver no longer existed. The man left limping at daybreak was now Israel—which means "He Who Wrestles with God."

But that isn't the end of the story. Jacob went on to ask for the name of his wrestling partner. Asking his opponent's name was the same as asking his wrestling partner to cry "Uncle!" Since a name contained someone's essence, the heart of his or her story, knowing someone's true name meant having a measure of authority and control over the person. Jacob wanted his opponent's name because he wanted to win.

Even when he was given another chance at redemption and rebirth, Jacob had the audacity to

try to grab one more thing for himself: the name of God. Yet God refused to give it to him. God revealed more about Himself to Jacob through His actions than through any name spoken aloud. Instead of offering a name Jacob could call to have power over Him, God revealed His nature to Jacob by intervening with power in his life.

Cling to God Alone

Jacob learned that the more he grasped at things, the more he lost. The more he let go, the more he gained. If we cling to anything but God, we will find ourselves sinking into a pit we've dug for ourselves. But if we let go and grab hold of God, we'll discover that we're closer to finding the peace, forgiveness, and transformation we long for. The fact that God loves us and chooses us is no guarantee that we won't struggle. But it is a guarantee that we won't struggle alone.

When we wrestle with the issues of life—even issues we've brought on ourselves—God will be right there wrestling with us, bringing a blessing, even when we don't deserve it. God will always be there to offer a new name and a new chance to be declared His children.

3

Remember that God Is Always at Work

Naomi

Have you ever felt stressed and overwhelmed by the circumstances of your life, hoping and praying that things would get better? We've all been there at one time or another. Life can be challenging, difficult, and painful—sometimes even tragic. None of us is exempt from the struggles of this world. Yet as people of faith, we have this hope: God is *always* at work in our lives, even when it doesn't appear so.

God is continuously working on our behalf, oftentimes behind the scenes, to bring about His plans and purposes for our lives. He is in the process of transforming us, making us new creations in the image of His Son. Sometimes we just need to have eyes to see. And sometimes

the story of someone else can help to open our eyes—someone like Naomi.

From Pleasant to Bitter

Naomi's life was torn apart when she lost everything she knew and loved. In the very first verse of the book of Ruth we learn that Naomi's homeland was rocked by such severe famine that her family was forced to evacuate, becoming refugees in the neighboring country of Moab. The first loss Naomi experienced was the loss of her livelihood—her own sustenance and her ability to feed her family. This led to the loss of her home, her friends, and the familiarity of all that she knew as she and her husband fled to another country with their two boys just to survive.

If these were Naomi's only losses we would feel sorry for her, but they were nothing compared to the losses yet to come.

All within a few verses Naomi lost the three most important people in her life—her husband and two sons. Her family was torn apart. How did Naomi react? Not surprisingly, she was grief-stricken, bitter, and angry at God. When she decided to return to her homeland, her daughters-

in-law were loyal to her and wanted to stay with her, even though they were grieving the losses of their own husbands. But Naomi urged them to return home. One of them, Orpah, chose to return to her parents. But Ruth refused to go back. Her words, powerful and beautiful, have a poetry that has made them classic:

> *"Where you go I will go, and where you stay I will stay. Your people will be my people and your God my God. Where you die I will die, and there I will be buried. May the LORD deal with me, be it ever so severely, if anything but death separates you and me." When Naomi realized that Ruth was determined to go with her, she stopped urging her.*

> Ruth 1:16-18

With these words, Ruth was forming a covenant friendship with Naomi. Their connection as a family was severed by the death of Ruth's husband, Naomi's son. Ruth's covenant reinstated the bonds of family between them. Stronger than a contract, a covenant has at its center the God they would both worship and follow. They would

need God's strength to carry them through the difficult days ahead.

After Naomi and Ruth returned to Bethlehem, the women in the town were so surprised to see Naomi again. They exclaimed, "Can this be Naomi?" Naomi, whose name means "Pleasant," was in such a despairing emotional state that she changed her own name:

> *"Don't call me Naomi," she told them. "Call me Mara, because the Almighty has made my life very bitter. I went away full, but the LORD has brought me back empty. Why call me Naomi? The LORD has afflicted me; the Almighty has brought misfortune upon me."*
>
> Ruth 1:20-21

Naomi decided that "Bitter" was the name that best applied to her current identity. She let the grief take over and name her with heartache.

Naomi's reaction isn't that surprising, really. How can we blame her for holding God responsible for the avalanche of tragedies she endured? When there's no easy explanation or person to blame, God is often the target for our anger. But God can take it, and God has heard it all before. As the psalms

illustrate so beautifully, we never have to gloss things over in prayer, afraid of God's reaction, or try to hide our negative feelings from Him.

Scripture never condemns Naomi's anger at God, and God didn't withhold any future goodness or blessing from her life just because she was angry with Him. No, instead of turning away from Naomi in her grief or leaving her to stew in her own bitterness, God continued to offer her His grace and love. And one of the ways He did this was through the friendship of Ruth.

Ruth Takes Action

Ruth experienced the same kinds of loss that we see in Naomi's story. She also was grieving the loss of her husband, as well as her father-in-law and brother-in-law. She may have even gone through similar stages of anger and depression. But in chapter 2, Ruth's grief begins to take on a different shape.

When they arrived in Bethlehem, Ruth found herself in a desperate situation. In that particular time and culture, the male members of the household would work to supply food and shelter for their family. Ruth and Naomi had no one to

provide for them. If no one took action on their behalf, it was possible that they could starve or be forced to beg on the streets.

Instead of wallowing or waiting for someone else to take responsibility, Ruth channeled her grief, worry, and anxiety into action. With Naomi's blessing, she went to the fields each day to glean— to gather the leftovers the harvesters had dropped. She worked tirelessly until sundown, and we're told she worked the entire season until the harvest had finished. Ruth's initiative and determination saved her life and Naomi's, and it set into motion a course of events that would change their lives forever.

First, the owner of the fields in which Ruth worked each day noticed her determination. His name was Boaz, and he perceived that Ruth was a remarkable young woman. He saw that she wasn't expecting anyone to do something for her, but instead she did something for herself and her family. And her take-charge attitude inspired Boaz to help her succeed. He not only invited her to glean in his fields, but he also told the men not to lay a hand on her, invited her to get a drink from the water jars whenever she was thirsty, and invited her to sit by him at mealtime and eat. Then

he gave orders for her to be allowed to gather among the sheaves without being reprimanded.

When Ruth returned home with an amount of barley that was obviously more than she could have gathered under normal circumstances, Naomi knew something was up. Ruth obviously had help.

Ruth's initiative to care for Naomi inspired a domino effect of compassion that completely turned their lives around. Ruth's heart of service toward Naomi inspired Boaz to help her. And in turn, watching Ruth's tireless hard work and kindness and learning of Boaz's acts of compassion helped wake Naomi from her fog of grief. Her sense of hope began to return. She saw Ruth's plan of action to keep them alive and, after coming to an important realization about Boaz, she began to come up with a plan of her own, a plan so controversial it had to be done under the cover of darkness.

An Important Realization

Naomi discovered that Boaz was not only a kind landowner but also a close relative and their kinsman-redeemer. In Hebrew, kinsman-

redeemer is "go'el." That title describes a role given by the law in Leviticus to a man who would help out a family member in distress by "redeeming" them. The law of Israel declared that a kinsman-redeemer was responsible to redeem a relative who had fallen on hard times and needed rescue. A true *go'el* would marry a widow of his closest male relative and give inheritance to those children even though they'd be considered the children of the deceased. This is why Naomi could say that Yahweh had not forgotten His kindness even to the dead (Ruth 2:20).

Naomi's plan was to get Boaz to marry Ruth and restore their family to financial health and standing in the community. To Naomi's credit, she recognized right away that it was God who was at work through these circumstances. She had been quick to blame God when things went wrong, but now she was quick to praise Him when she saw something happening that she knew was too wonderfully planned to be coincidental.

One of my favorite phrases in Naomi's story is found toward the beginning of chapter 2: "As it turned out, [Ruth] found herself working in a field belonging to Boaz, who was from the clan

of Elimelech" (verse 3). The phrase "As it turned out" could also be translated "As luck would have it." This is one of the greatest understatements in the Bible! The fact that Ruth "coincidentally" ended up in the fields belonging to Boaz, the one person in all of Bethlehem with the position and compassion to help Ruth and Naomi, is what brings about the eventual happy ending for all of the members of this family.

It wasn't luck that changed their lives for the better. No, clearly God was at work here—working behind the scenes as the true Kinsman-Redeemer. God, their true Redeemer, came to their rescue through a human kinsman-redeemer. Boaz might have been the *go'el* redeeming them from a life of poverty and hunger, but God was the great *Go'el* behind the scenes, redeeming their story of grief and brokenness, bringing light where there was only darkness.

Naomi realized that all along God had been acting and working behind the scenes. It was at that point that Naomi stopped focusing on the negative past and began to work for positive change for a future for her and Ruth.

A Better Story

Naomi's plan succeeded. Ruth and Boaz married, and they had a son, Obed. At the end of the book of Ruth, the same women of Bethlehem that Naomi told not to call her Naomi (Pleasant) anymore, but to call her Mara (Bitter), were now praising God for the circumstances He used to bring her joy (Ruth 4:14-15).

But that's not the end of the story! Obed grew up, married, and had a son. This son, Jesse, became the father of King David, the most influential king Israel ever knew. And Jesus Himself, the long-awaited Messiah, eventually descended from his lineage. God rewrote Naomi's story, giving it a better ending than she ever could have imagined!

God loves to work in secret and see if we can uncover His goodness. He is working not only for our good—for each of our small stories—but also for the good of His creation—for the Big Story that is always greater than anything we can wrap our minds around. What appears to be a happy ending for Naomi is really a beginning of a new and grander story for us all.

Naomi's story opens our eyes to God's presence with us even in the midst of our own trials and

heartaches and gives us hope. Her story reminds us that God promises always to walk with us through the difficult times, helping us to put the pieces of our lives back together and rewrite a better story. Whatever our circumstances may be, God will lead us toward a bright and hope-filled future.

4

Be Set Apart for God

Daniel

When God rewrites our stories, God changes our priorities. God knows that whatever is at the center of our lives is what we worship, and trouble arises when we begin to worship anything other than Him.

God wants to refocus our gaze on Him and to equip us to live our lives for His glory—to set us apart for His purposes. As we allow God to transform us, we begin to act in order to call attention to God; we live for His name's sake, not for our own. When we live this way, people see His nature reflected in our actions and are drawn to His love.

That is exactly what happened in the lives of Daniel and three of his friends. Their stories demonstrate a critical key to a transformed life: being set apart for God.

Once Upon a Time in Jerusalem

Once upon a time in ancient Jerusalem, four sets of parents began teaching their children what their families believed and what shape their lives were expected to take on the day they were born. They did this by giving them their names. The four boys were named Daniel, Hananiah, Mishael, and Azariah. Their parents knew the first lesson they wanted to teach their sons: that they should honor and worship God in all they did. They felt so strongly about teaching this lesson that they embedded it in their very names. Consider the meanings of their names:

> Daniel—God is my judge
> Hananiah—Yahweh is gracious
> Mishael—Who is like God?
> Azariah—Yahweh has helped

Each time these boys heard their names, they heard a message about a powerful God who loved and cared for them.

We don't know anything else about Daniel, Hananiah, Mishael, and Azariah's families, but we do know that they made a conscious effort

from the first day of their lives to teach them about God and let them know that worshipping the one true God was part of the culture they were born into.

I wonder if those families had a sense of the impending destruction of their surrounding culture and way of life. The Babylonians, under the leadership of King Nebuchadnezzar, invaded and destroyed Jerusalem in 605 B.C., destroying the city and the Temple, the place where they worshipped. The four boys with God-centered names were probably in their early teen years when they became prisoners of war, taken back to the evil empire of Babylon.

Nebuchadnezzar wanted more than the destruction of the structure of the city; he wanted to conquer the hearts and minds of the leaders of the next generation, instilling in them a Babylonian way of life. He did this by taking an entire generation of leaders back to Babylon, where they would be treated not as prisoners-of-war or slaves but as trainees for positions of leadership, influence, and power. The king knew that if he could convert one generation away from their own religion and way of life, he would reach his goal.

True to Their Roots

The challenges to their integrity and faithfulness to God were immediate upon arrival in Babylon. First, the Babylonians took the names that these young men's parents had given them to honor God and replaced them with names that honored the idols worshipped in Babylon.

Not only were they renamed; their first meal called their beliefs into question. Immediately they were confronted with the choice of whether to eat food sacrificed to Babylonian idols, a form of participating in idol worship. Where others saw an opportunity to live a new and lavish lifestyle, especially after being plucked from a devastated war zone, Daniel and his friends refused to defile themselves in this way.

So, Daniel persuaded the guard that the chief official had appointed over them to allow them to eat only vegetables and drink water for ten days and see how their appearance compared to the other young men eating the royal food. And at the end of the experiment, they looked healthier and better nourished than any of the others.

These young men were able to withstand the temptation to gorge themselves on delicious food

because they knew it would betray the God they loved. Even though they were young, they stood up to the Babylonians and remained true to their names. Their family culture was so embedded in them that even when they were removed from it and transplanted to a pagan environment, their beliefs did not budge.

To Bow or Not to Bow

If eating food that had been on the altar of idols seemed like a small thing, Hananiah, Mishael, and Azariah were given bigger challenges soon enough. They faced a decision about whether to bow down to a ninety-foot-high golden idol statue built by King Nebuchadnezzar. They must have stood out, quite literally, as the crowd around them bowed and they were the sole people left standing in the presence of the huge idol.

When Hananiah, Mishael, and Azariah refused to bow before the statue, the king's anger burned so greatly that he ordered them to be tied and thrown into a blazing furnace heated seven times hotter than usual. They weren't excused from the fiery furnace just because they did the right thing in God's eyes. They were not

immune to the earthly consequences of their actions, however unfair and unjust they were. The miracle came, though, when those watching saw not three people in the fire, but four! King Nebuchadnezzar approached the furnace and shouted for Shadrach, Meshach, and Abednego to come out. So they came out, and everyone saw that they were unharmed. Not even one hair of their heads was singed! Nebuchadnezzar praised God and decreed that no one could say anything against their God (Daniel 3:24-29). Their faithful witness resulted in an amazing demonstration of the power of God, causing the very king who had demanded that everyone bow to his image now to proclaim God's praises.

Like Hananiah, Mishael, and Azariah, we can't always be sure of our earthly safety because we are God's followers, but we can be sure that God goes with us into even the most fiery of situations. When we stand for God, we don't stand alone; He always stands with us—ready and able to do powerful things through our faithfulness.

A Faithful Worshipper

Some years later, after a different king was on the throne, Daniel found himself in a tough

situation. A decree from King Darius said that no one could worship or pray to anyone but the king for a full month. This law was orchestrated by his enemies who were deliberately trying to trap him. They knew that Daniel prayed to his God three times a day in the same place, facing Jerusalem, and so they planned to get him in trouble by making a law against prayer.

Despite the decree, Daniel was faithful to worship God. And just as Hananiah, Mishael, and Azariah could not escape the consequences of their right choice, neither could Daniel. Those who were plotting against him went straight to the king, telling him that Daniel was violating the king's decree. Though the king wanted to rescue Daniel, his decree could not be revoked. So Daniel was thrown into the lions' den. A stone was placed over the mouth of the den, and the king sealed it with his own signet ring.

Daniel spent a long night in that lions' den, waiting to see if he would become their midnight snack. The next morning, after a restless night, the king rushed to the lions' den and called out to see if Daniel had been eaten. Miraculously, Daniel called back, announcing that God had sent His angel to close the mouths of the lions. Not one scratch was to be found on Daniel.

The king who had demanded that everyone pray only to him now issued another decree, requiring the people in every part of his kingdom to fear and reverence the God of Daniel who had rescued him from the power of the lions (Daniel 6:26-27).

Daniel's faithful worship had prepared him to face the lions' den, and the outcome was the spread of God's glory and fame.

Set Apart for God's Glory

Though we haven't had the exact experiences as Daniel and his friends, we live in a culture that tries to give us new names and identities and get us to worship things other than God. Our culture has its own specific gods, just as the Babylonians did.

You can make a pretty good argument that the culture we live in worships celebrities, wealth, beauty, technology, and power. But mostly, I think, our culture invites us to worship ourselves. Advertising is built entirely on this principle— that you deserve to look a certain way, buy certain products, drive a certain car, and live in a certain neighborhood because you are the most important

figure in the universe. *You are your god,* the ads whisper. Our culture will cheer you on if you work to make an idol of yourself.

We desperately need to find the secret to the story of Daniel and his friends. Rather than copying the Babylonian culture and worshipping their idols, Daniel and his friends actually pointed the people to God. Even though in these particular instances Daniel and his friends were promoted and their own lives benefitted, the true outcome of their actions was to build up God's name, not their own. They were set apart for God, and their actions pointed people to honor God alone.

Likewise, when we live our lives for God and allow Him to transform us, what we do bears witness to God's character, witnessing to the work He is doing in us and drawing others to Him. God calls us to live so differently from the people around us that they take notice. He calls us to live the way Jesus did.

Daniel, Hananiah, Mishael, and Azariah had God's name embedded in their own names. When we make a pledge to follow Jesus, He gives us the name "Christian" to wear—a title that has the very name of Christ embedded in it. If we

allow Him to continually transform our hearts and actions, we will bring honor and praise not to ourselves but to Christ, for His name's sake.

5

Embrace God's Grace

Peter

In our instant-everything culture, we tend to get discouraged when the process of transformation takes longer than we think it should. Most of us would love a microwave solution, but more often transformation is like a slow cooker. God works with us in the slow movement of grace that literally takes a lifetime. And God's grace is big enough to cover our many stumbles and falls along the way.

Simon Peter's story encourages us because his process of transformation continued long after he met Jesus. He made mistakes and even denied Jesus, yet God never gave up on him. In fact, despite Peter's flaws and failures, God saw within him something He could use and cultivate for His glory. Peter's story reminds us that no matter what, God hasn't given up on us or the future He

has planned for us—and He never will. As Peter learned, embracing God's amazing grace is an essential key to our transformation.

An Unlikely Choice

When we read the story of Simon, there is no denying that this guy was no saint! In fact, when Simon answered the call to follow Jesus, he was impulsive, brash, immature, and reckless. His temper flared and he usually spoke up before his brain could intervene. Jesus knew He had His work cut out for Him where Simon was concerned. But for some reason, Jesus chose Simon. Not only was he chosen to be a follower; he was chosen as a leader for the disciples and the ragtag collection of imperfect people who would come to be called the church.

Simon led the group in many of the Gospel stories. Sometimes his leadership was intentional, planned, and strategic. Sometimes it seemed almost accidental—an inadvertent byproduct of his reckless, impulsive nature. And sometimes it seemed that the other disciples hung back, letting Simon stick his neck out and take the risks they didn't want to take.

Although at times his risky behavior got him in trouble, there were other times when he landed on the right answer—almost by accident. Never was that more true than on the day that Jesus changed Simon's name. Jesus was giving His disciples a pop quiz. He first asked them, "Who do others say that I am?" It was easy to tell Jesus what they had overheard from the crowds of people around them.

Once they had passed the easy portion of the test, Jesus asked them, "Who do *you* say that I am?" It was one of those questions that required them to think about all they had heard and seen in their time with Jesus, to put the facts together, and then to create an answer that matched their experiences, observations, beliefs, and feelings about Jesus. They all hesitated at that point. All of them, that is, except Simon.

I doubt that Simon stopped to think about what the other disciples would think or if he had an answer that Jesus would like. In keeping with his impulsive nature, he probably simply reacted, saying, "You are the Christ, the Son of the living God" (Matthew 16:16). No one had told Simon that Jesus was the Messiah (the Christ), the One that all of Israel had awaited for so long. He seemed to blurt it out in a moment of passion.

And for once it was just the right thing to say. Jesus rewarded Simon with a response that must have stunned the other disciples:

Jesus replied, "Blessed are you, Simon son of Jonah, for this was not revealed to you by man, but by my Father in heaven. And I tell you that you are Peter, and on this rock I will build my church, and the gates of Hades will not overcome it."

Matthew 16:17-18

The name Simon means "He Hears and Obeys." This name had hung around his neck like an oversized sweater that never quite fit. He never really listened much. He was too busy blurting out the first thing on his mind. And obedience continued to be a struggle for him throughout the Gospel stories.

The new name Jesus gave him, Peter, means "Rock, Boulder." It describes a solid foundation. At first it didn't seem any more appropriate than the name he had before. But what Jesus said next tells us something about His reasoning for choosing this impetuous follower to lead the pack: "On this rock I will build my church" (verse 18). The phrase

"I will build" means that Jesus was willing to call someone who was a work in progress, someone on whom He could build a vision, a foundation for the future of His church. Jesus was claiming Simon because he was great building material, not because he was a finished product.

The reasons God is attracted to us as followers today has nothing to do with anything we've already built ourselves up to be. It has everything to do with His unconditional love for us *just as we are*.

A Life of Ups and Downs

Like most of us, Peter's old life seemed to follow him like a shadow. He possessed both a desire to change and a resistance to change that makes his life resemble a spiritual yo-yo. While Peter did change and grow as he walked with Jesus, the same flaws he had as a brash fisherman when Jesus called him beside the sea were still present even after he became the leader of the disciples.

Not long after Peter boldly declared that Jesus was the Christ, the Son of God, another outburst had him standing squarely in Jesus' path,

blocking the way to God's mission on earth. Jesus had just explained to the disciples that he must go to Jerusalem where he would suffer, die, and rise again from the dead. Although God's people had been waiting and hoping for a Messiah for thousands of years, their understanding of what the Messiah would do never included suffering or death on a cross.

Peter took Jesus aside and began to rebuke Him, saying that must never happen. Jesus turned to him and said, "Get behind me, Satan! You are a stumbling block to me; you do not have in mind the concerns of God, but merely human concerns" (Matthew 16:23). Just as quickly as Peter became the hero of the day through his understanding of Jesus' identity as Messiah, his misunderstanding of the role of Messiah instantly made him a hindrance to God's mission. Peter learned in that moment that his words not only could make him a mouthpiece for God but they also could make him a tool of Satan, a stumbling block standing in the way of the very calling that Jesus had come to earth to fulfill.

That is only the first of several times in Scripture that we see Peter reverting back to his old ways.

At the Last Supper, in a shocking act of servanthood, Jesus offered to wash the disciples' feet. Instead of celebrating the moment or waiting to see what Jesus might be trying to teach him, Peter recoiled and rebuked Jesus: "'No!' [he] said. 'You will never wash my feet!'" (John 13:6-10 CEB). Then, when Jesus explained His purpose in washing their feet, Peter begged for Jesus to wash all of him (John 13:9-10). Again his impulsivity brought to light both the worst and the best in his heart.

Peter's up and down tendency is reflected even in Scripture's use of his name. Perhaps you've noticed that the Bible often uses his old and new names interchangeably. The truth is that sometimes Peter lived up to his new name. Other times he acted more like his pre-Jesus self. At those times Jesus called him "Simon," pointing out that he was acting like his old self and not the Rock that Jesus had called him to become.

One time Jesus admonished Peter by using his old name not once but twice. The disciples were gathered in the upper room for the Last Supper. After supper, an argument arose about who would be the greatest in the kingdom of heaven. It was then that this exchange took place between Jesus and Peter:

"Simon, Simon, Satan has asked to sift you as wheat. But I have prayed for you, Simon, that your faith may not fail. And when you have turned back, strengthen your brothers."

But he replied, "Lord, I am ready to go with you to prison and to death."

Jesus answered, "I tell you, Peter, before the rooster crows today, you will deny three times that you know me."

Luke 22:31-34

Peter was asserting that he would never be the one to betray Jesus, to disappoint the Savior he loved. Jesus knew better. He predicted that before the cock crowed, Peter would deny Jesus not once but three times. And that's exactly what happened.

Jesus knew that Peter would disappoint Him by denying Him. But He also knew that Peter wouldn't stay down long. He prayed that this moment of struggle would be one that would strengthen Peter, and that when He bounced back He would strengthen His brothers as well.

There are numerous examples of these up and down moments in Scripture when Peter is referred to by his old name and by his new name. But even more often in Scripture he is referred to

as Simon Peter, a nod to his old and new nature mixed together in one. If we're honest, most of us are also a mix of the old and the new, a work in progress with Jesus gradually helping us subtract the negative and add the positive. If we learn anything from Peter, it's that it certainly takes some time to work out our spiritual kinks.

Sometimes we have the idea that a life committed to Christ will be instantly better. This leads people to the expectation that the moment their lives are in Jesus' hands, they won't struggle anymore—that their flaws will melt away and their temptations will fade. But the truth is that all the same temptations, struggles, and character flaws that drove you into the arms of Christ will follow you there. The difference is that Jesus is there to help you with all of it. Jesus is the One with the power to enable each of us to live a transformed life.

Even as we walk with God, we will sometimes fall down again, often in the same potholes we fell into before. But there is always hope and grace and forgiveness. Thank God He has the patience and grace to work on us over the long haul.

Yes, Peter's journey is characterized by ups and downs along the way. Sometimes he shows his rock-like faith by walking on water to meet

Jesus. Sometimes he sinks like a stone. But as we follow his life, we'll find that he does change and grow and ultimately live into the name Jesus has given him.

Your journey likely has ups and downs as well. Sometimes you may look like a poster-child for the changes faith can bring. Other times you may find yourself sinking back into your old habits. Up or down, know that God is with you, and that His love for you does not change with the whims of your behavior. He is writing a new story for your life, and that story has grace spelled out on every page.

Another Chance to Embrace Grace

Peter's story certainly has grace spelled out on every page, and it's no accident that the number three appears over and over again in this story of grace, helping to tie the pieces together.

After Jesus asked the *three* leading disciples to stay awake and pray with Him, He returned *three* times to find them sleeping. When Jesus was arrested and dragged away to be beaten and put on trial, Peter followed at a distance. Those events must have seemed so unbelievable, so

horrible. In the middle of it all, *three* different people recognized Peter as a follower of Jesus. At the very moment Jesus needed Peter's support the most, strong Peter melted into the old Simon and denied that he even knew Jesus—not once, not twice, but *three* times. His mind must have flashed back to the conversation when Jesus predicted that betrayal with eerie accuracy. The feelings of failure and shame must have been overwhelming to Peter. Not only had he let down his Savior but he had done it even after Jesus had predicted, and even warned him about it!

Here is where Peter needed forgiveness the most. This was his moment of greatest need, and this is where Jesus really triumphed.

After Jesus rose from the dead, He appeared to the disciples. The third time He appeared to them, He met Peter in the exact place where they had begun—on the seashore. Calling out from the shore, Jesus gave fishing instructions to the most seasoned fishermen, and the nets were so full they almost broke. When Peter finally recognized it was the Lord, he dove into the water and swam to shore.

Jesus had cooked breakfast for them, and after they ate, He spoke directly to Peter: "Simon,

do you love me?" After three knife-in-the-heart denials the night Jesus died, Peter was given three chances to answer this all-important question. With each one, Jesus used his old name, his original name, Simon. Using this name said, "I know who you are, and I love you anyway. I know your struggle and pain, and I know that you are your own worst enemy; and I'm still here to offer you help."

Three times Jesus asked if Peter loved Him, and three times Peter answered yes. Then Jesus called out to him, "Follow me!" That call must have felt like déjà vu. Those were the words of his original calling. Now they were the words that called him back, letting him know that Jesus wanted him to follow in the same way as he did that first day, just as much now that Jesus had seen him at his worst as in the very beginning.

Suddenly it all added up. It didn't matter to Jesus who the world said that He was; He had wanted to know, "Who do you say that I am?" It didn't matter to Him what Simon had done. He wanted to know, "Do you love me?" And three times Simon jumped at the chance to answer "Yes!"

You know, I often stumble, showing my old colors beneath all the work Jesus has done in me.

I tell Jesus "Never!" when I should say, "Anything you ask, Lord." I fall asleep when I should be standing by Him. I betray and deny Him not once but over and over. And yet He still finds the sum of my behavior to be nothing compared to His great love and sacrifice for me.

For every mistake we make, Jesus gives us one more chance. He gives us the chance of a fresh start. He continually goes before us and asks us to follow Him. No matter how many times we mess up, He offers us forgiveness, followed by an invitation just like the first: "Follow me."

Jesus always offers us another chance to answer that singularly most important question: "Do you love me?" He extends His grace freely with no strings attached. All we have to do is embrace it!

6

Choose a Different Future

Unnamed

Often in life we can feel trapped—doomed to repeat our mistakes. Sometimes we are branded by the past, named for our sin. Yet when all appears to be lost and no one seems to care, there is Someone who not only loves us unconditionally but also has the power to wipe our slate clean and give us a brand new start. Jesus offers us forgiveness, setting us free from the past, and then He calls us to choose a different future—a future made possible by His grace and power.

An unnamed woman in Scripture who was labeled by her sin had this very kind of encounter with Jesus. Her story encourages us to accept Jesus' forgiveness and choose a different future. It's a choice that changes everything.

Unnamed but Not Unknown

Because of one mistake, one moment in her life she wasn't particularly proud of, this unnamed woman received a nickname that marks her in every Bible that has ever been printed as "The Woman Caught in Adultery." She was literally dragged onstage in the opening act of her own story by a group of men who were, shall we say, a little too excited about someone else's sin. They were probably keyed up and out of breath, calling out to Jesus in animated voices: "Jesus! Here's a woman caught in the very moment of her sin! We know what the law says should be done with a woman like this. What do you say?"

It's clear from the story that these men weren't interested in justice. They weren't even interested in the woman. What they were interested in was Jesus—specifically, catching Him in a trap.

If He agreed with them and with the law of Moses, saying they should stone her, He would be seizing power away from the law of Rome, and the Romans would have His head. If He went against the law of Moses and said she should go free without punishment, He would be defying the law of Moses and likely would lose the respect of the crowds who had been following Him.

They had Him cornered right where they wanted Him. At the least, they could split the crowd's opinion of Him, reducing the size of His following by half. And if they were successful, they might even set in motion events that would lead not to the woman's execution but to Jesus' own death.

If they truly had been interested in law and justice, there likely would have been another person present and named in the story. In Jewish law, no one could be proven guilty without the testimony of two witnesses. You couldn't just be "the woman accused of adultery" or "the woman suspected of adultery." You had to be caught in the act, and you had to be caught by two eyewitnesses. So these men went to a lot of trouble to have two people catch this woman in the act while letting her partner slip out the back door.

The way they used this woman for their own agenda, shaming her in a public place (the Temple, no less) shows just how little concern they had for her as a person. It's possible that she had been treated with contempt by other men in her life, that she was all too familiar with men who used her for their own purposes without truly knowing her heart, her hurts, or even her name.

Now standing before her was one more man, a teacher of the very law that she was accused of breaking. One condemning word from Him and she'd be dragged out and stoned. A forgiving word and her life would be spared. Her life was in His hands.

As onlookers to her story, we have the benefit of information that our frightened, unnamed friend did not have in those anxious moments. We know the good news that the man standing before her was different than anyone she had ever met. He wasn't only a man; He was also her Creator and her God, and He loved her more than anyone ever could.

Waiting for a Verdict

You can bet that the crowd got quiet as they waited for Jesus' decision. All eyes were on Jesus. But Jesus wasn't looking back at any of them. He was looking at the ground. And while they watched, "Jesus bent down and started to write on the ground with his finger" (John 8:6). This made them all the more curious. What was He writing? The text doesn't tell us.

The Greek verb used for *write* indicates more than just doodling or drawing. It specifies that Jesus was writing words. Scholars who have studied this text have guessed, discussed, and guessed some more about what Jesus was writing on the ground.

Maybe He was writing out a list of the Ten Commandments or the sins of her accusers—so that they would recognize that none of them was above reproach. Maybe He was writing out the names of the men there who were also guilty of adultery. One particular guess I like is that Jesus might have been writing her name, humanizing this unknown woman with the unspoken proclamation *She is more than her sin; she has a name*.

Her accusers were guilty of a different kind of sin. They were worshipping an idol. Their idolatry was the worship of the law itself. They cared far more about the law than they did about a relationship with the God behind it. They wanted to use the law to prove they were more holy than those around them. They were more concerned with the law God wrote than the people God loved. And Jesus was fully aware of this.

As Jesus stooped and wrote on the ground that day, His message—whatever He might have

written—somehow sunk deeper than just the dirt in which He wrote. It cut straight to the hearts of those who were watching and listening. When Jesus stood, He said, "He who is without sin among you, let him throw the first stone at her" (John 8:7 WEB). The men who had wielded the law like a weapon, both against the woman and against Jesus, were redirected to look within their own hearts. Finally they stopped looking at her or at Jesus and started looking at themselves. And they gave up their quest and began, one by one, to walk away.

Jesus, with just one sentence, stopped them in their tracks. Instead of looking at the sins of others, He told them, take a look inside yourself. The question was not *What sin do you find in her?* but *What sin do you find in your own heart?*

When these men, so bold in their accusations, turned their judging eyes on themselves, they became all too aware that none of them lived up to the standard of sinlessness Jesus was holding up. The only one in that crowd who was without sin was the One offering that challenge, and He wasn't picking up any stones.

This woman's story shows us that God does want us to be on the lookout for sin, but the place

He wants us to look is within ourselves. When we do, we will always find room for improvement. It also shows us how to look within the heart of God and find compassion and grace. The intersection of our heart marred by sin and the heart of Jesus, sinless and ready to forgive, is a beautiful place. Honesty about our need for God's powerful and undeserved grace is the only thing that will drive us to confession and forgiveness, the true place of freedom. While others hurl judgment, Jesus offers grace.

Grace and a Choice

After all of her accusers had left, Jesus asked the woman where they had gone and if anyone had condemned her. She told him no one. Then Jesus said, "Neither do I condemn you. Go, and from now on sin no more" (John 8:11 ESV). In that moment He offered her release and responsibility. His statements strike such a delicate balance. First He forgave her; then He set her on a new course in life. He gave her freedom from the past and a new path for the future, all in just two short phrases.

If Jesus had left her with that first statement, "Neither do I condemn you," She would have

walked away free but probably would have walked right back into her life of sin. Yet He didn't stop there. Jesus could have comforted her with a "There, there" and sent her on her way. He could have said, "Go, and be yourself; you're OK just the way you are"; "Go, and continue your relationship–you can't help who you love. All love is OK in my eyes"; "Go and enjoy yourself, you deserve to have a little fun." Instead, He gave her a gentle command: "Go, and . . . sin no more" (John 8:11 ESV).

"Sin no more" means God wants a better life for us than the one we've been leading. It means we have the responsibility to deal with our own impulses, desires, and temptations. It means that not only does Jesus want to forgive us and set us free from our pasts; He wants that freedom to stretch into our futures as well. He wants to eradicate sin from its iron grip on our lives.

When we look at Jesus' interaction with the woman caught in adultery, we don't find even a hint of condemnation. What we do find is an offer to change with His help, an offer at a life that won't keep damaging her, an offer to stop being branded by her past. Jesus wanted to free her from the voice of condemnation and the path that held her captive to her sins.

An Unwritten Ending

I've always felt a little frustrated that, like many other stories of Jesus' encounters in Scripture, we don't know the end of this woman's story. We don't know if she took Jesus up on His offer of a new life. Sometimes, though, I think stories like this are open ended so that we can imagine the ending ourselves. Envisioning her ending helps us, in a way, to ask what we want our own endings to be.

I wonder if you've ever felt the crushing weight of condemnation in your own life. Have you ever felt stuck in a rut of your own behavior or trapped by the mistakes of your past? The story of the unnamed woman is a gift for those of us who long to lead different lives with God's help. It unveils the beautiful balance Jesus achieves between releasing us from condemnation and offering us responsibility and freedom to choose a different future. That offer stands open for you today!